RYE
HISTORY TOUR

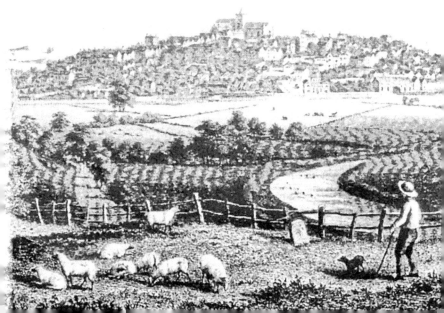

ACKOWLEDGEMENTS

Thanks are due to my collaborators in the earlier 'Through Time' book, Heidi Foster and my son Oliver Dickinson, and to my partner Lesley Voice for her support and good judgment in the preparation of this abridged version. Thanks are due to the Francis Frith Collection for permission to produce the image for entry 22 and to the various institutions and individuals who have lent photographs, in particular Rye Castle Museum for unlimited access to their photographic collection.

First published 2018

Amberley Publishing
The Hill, Stroud,
Gloucestershire, GL5 4EP
www.amberley-books.com

Copyright © Alan Dickinson, 2018
Map contains Ordnance Survey data
© Crown copyright and database
right [2018]

The right of Alan Dickinson to be identified as the Author of this work has been asserted in accordance with the Copyrights, Designs and Patents Act 1988.

British Library Cataloguing in Publication Data.
A catalogue record for this book is available from the British Library.

ISBN 978 1 4456 7813 9 (print)
ISBN 978 1 4456 7814 6 (ebook)

Origination by Amberley Publishing.
Printed in Great Britain.

INTRODUCTION

This volume on the historic hilltop port town of Rye in East Sussex is part of a series aiming to provide pocket-sized tours based on abridged versions of the Through Time series, which presented historic and current images together and provided the opportunity to explore issues of continuity and change. That was the third book that the author had produced and included fresh material. This abridged version therefore excludes many historic buildings and sites covered in the first two earlier books but takes the reader past or along all the main streets in the historic town centre.

This book is presented as three circular tours, which are all shown on the map. Each starts at a transport hub or tourist attraction and takes in a different area of the town:

Tour One: The Commercial Centre starts at the railway station and explores the area at the northern edge of the town, which developed as the main shopping and transport district. It includes the Landgate, the historic gate at the main land approach to the town.

Tour Two: The Top of the Town starts at the Ypres Tower, home of the Rye Castle Museum, and takes the reader to the main public buildings and the earliest market area including the church and town hall as well as the defensive sites of the tower and adjoining Gungarden.

Tour Three: The Strand starts at Rye Heritage Centre and looks at the main trading quay and the famous Mermaid Street.

All three routes take the reader to vantage points from which they may look out of the town to the surrounding rivers and countryside.

What of our themes of continuity and change? The former has been remarkable. The town has escaped wholesale new development and remains surrounded by fields and open spaces. How has this happened? Variously, it is due to the town's economic decline; its geographical location – Rye is surrounded by rivers – which limited development and encouraged industry to remain close to the town; corporation ownership of land around the town; and the advent of planning controls after the Second World War, which has protected the town's buildings.

While the buildings have not altered much in 150 years, change is, of course, apparent in costume, vehicles and street signs. Nearly all of the industries around the town have been abandoned or moved away, and leisure and tourism have taken their place. The town remains the centre of a boating and fishing community and has long been a centre for artists.

KEY

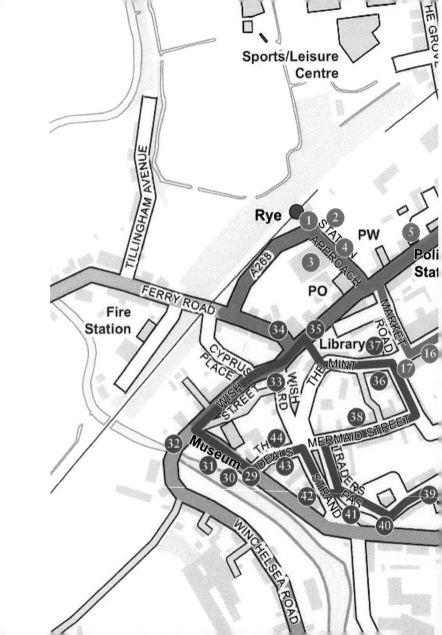

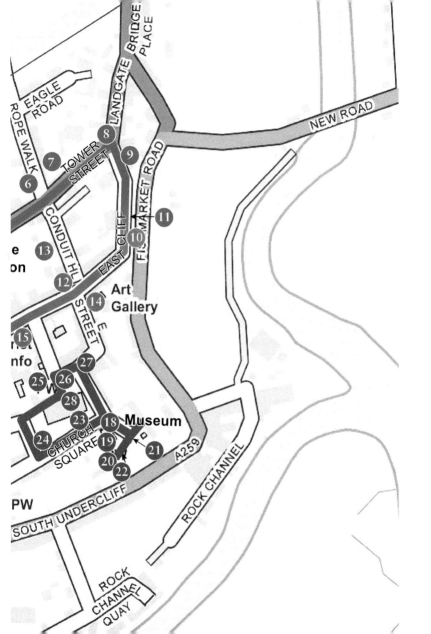

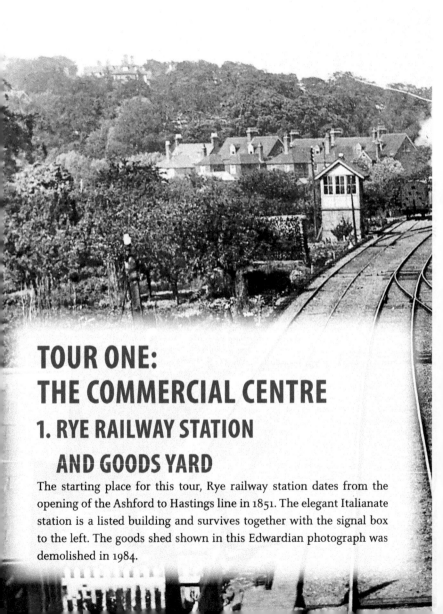

TOUR ONE:
THE COMMERCIAL CENTRE
1. RYE RAILWAY STATION
AND GOODS YARD

The starting place for this tour, Rye railway station dates from the opening of the Ashford to Hastings line in 1851. The elegant Italianate station is a listed building and survives together with the signal box to the left. The goods shed shown in this Edwardian photograph was demolished in 1984.

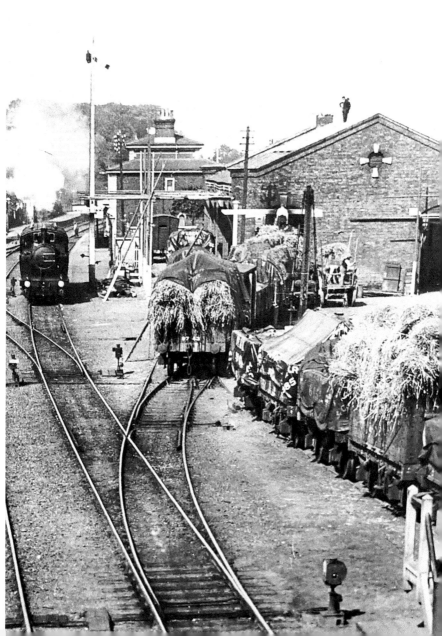

2. RYE STATION APPROACH

As you leave the railway station heading towards the town, the area ahead of you was a wide drive to Cinque Ports Street, now part of a one-way system and a taxi rank. It also hosted a part of Mayor Henry John Gasson's treat to the children of Rye in 1905.

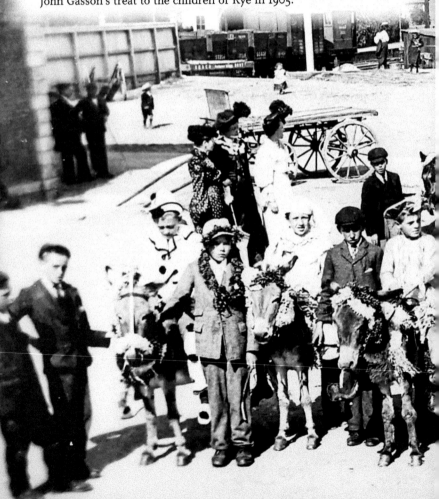

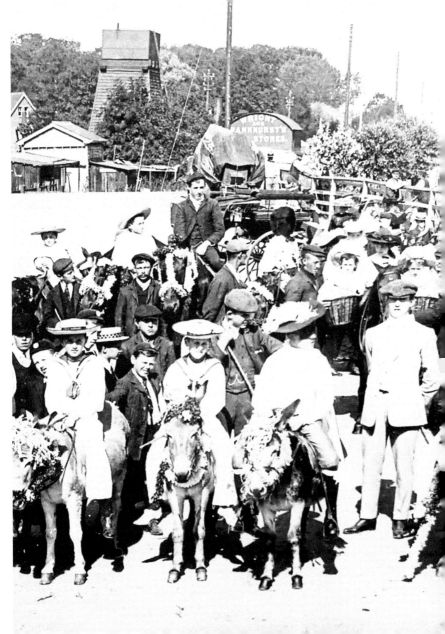

3. THE RED ROOFS OF RYE

Ahead of you is the characteristic pyramid shape of Rye, composed of red-tiled roofs and chimneys and crowned by the church. This early view was taken in 1859. Most of the buildings in the view are recognisable and are today a valued part of the street scene.

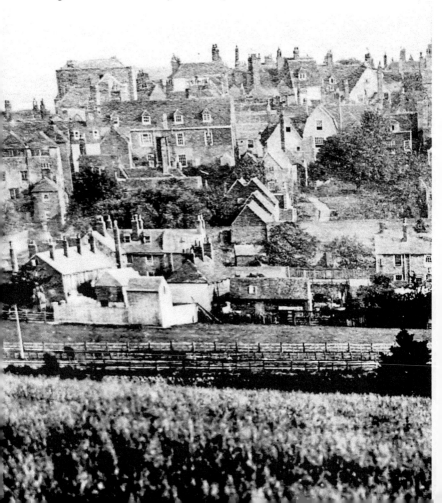

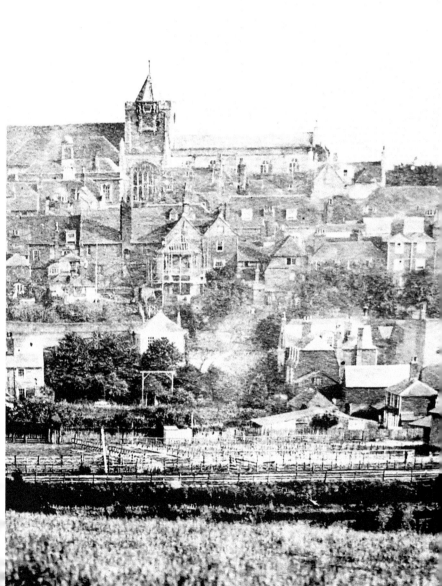

4. RYE MARKET

The site of Rye cattle market was on the left after it moved from Market Road in 1859. Paving and cast-iron pens were laid out and a market house was built for indoor sales. A second building was added, first known as the Agricultural Hall, now the Rope Walk Shopping Arcade. Livestock sales stopped in the 1980s. General markets continue on Thursdays.

5. THE FIRST REGENT CINEMA

Turning left at the head of station approach, Cinque Ports Street is a commercial road that grew up over and beyond the town ditch in the nineteenth century. The Regent Cinema was built in 1932, replacing the Electric Palace. It was destroyed by enemy action in 1942 and rebuilt. The cinema closed around 1980 and was replaced by the parade of shops and housing shown in the inset photograph. On the opposite side of the road the medieval town wall can be seen beyond the infilled ditch, now a car park.

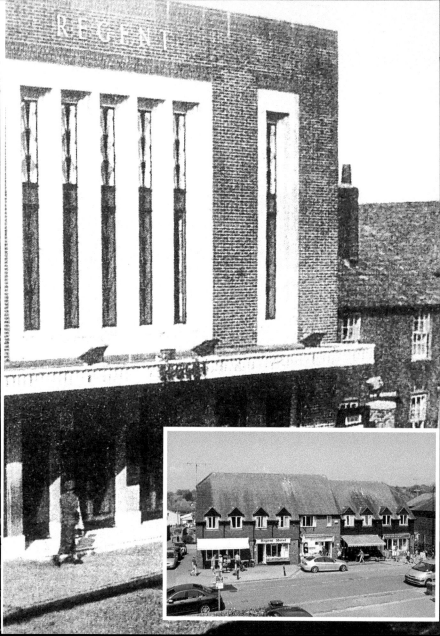

6. A SEVENTEENTH-CENTURY VIEW OF TOWER STREET

Ahead of you is Tower Street, named after the Landgate, the only surviving medieval gateway into the town. This remarkable street scene from the 1630s, by the court painter Van Dyke, shows the side view of the gate and the town wall to the right. An early water-pumping building is on the left and other buildings beyond are still recognisable, although altered. The modern inset view shows later housing obscuring the gate on the right.

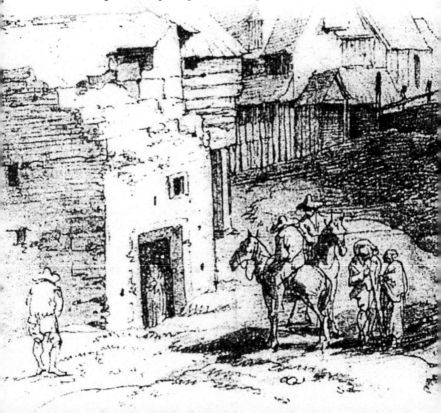

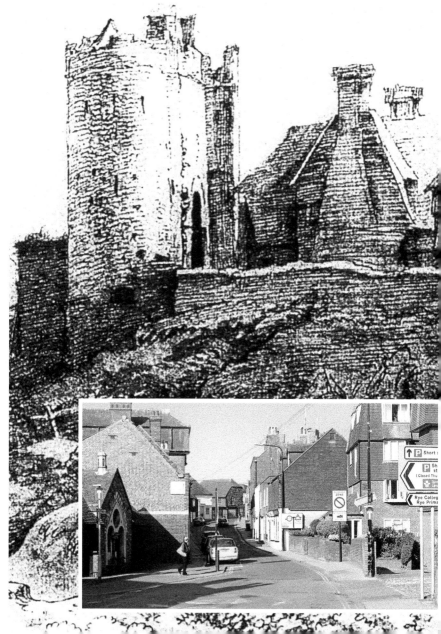

7. THE WATERWORKS

On your left is the later water-pumping station adjoining a secondary approach to the town in the medieval period through a postern gate in the town wall. The building served as a soup kitchen from 1895 for the relief of the town's poor.

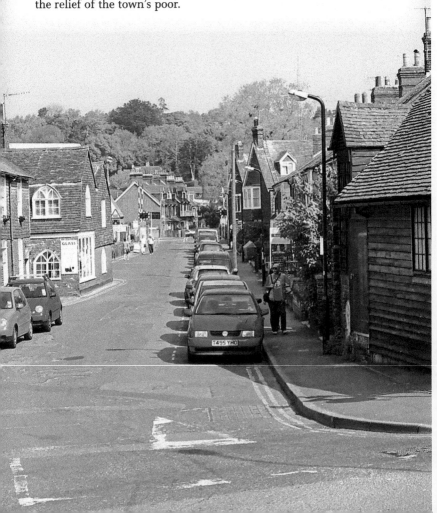

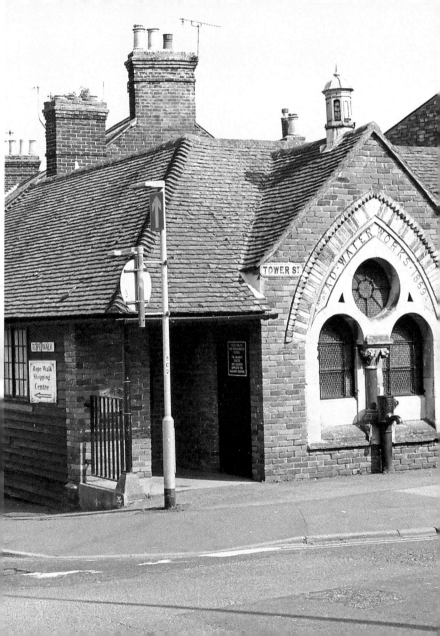

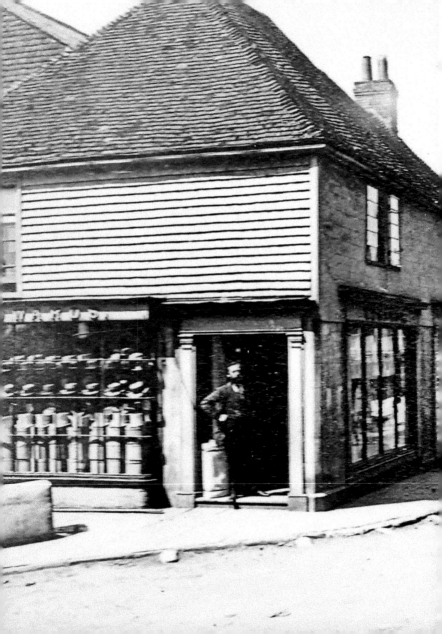

8. LANDGATE LOOKING NORTH

Turning to your left at the end of Tower Street, this view out of the town from the Landgate arch shows the main historic approach road into Rye from London, now a street named after the gate. The building on the left is shown on the Van Dyke drawing. It was built as a public house, The Rye Galley, over an earlier medieval stone vaulted cellar. This 1870s image shows its later use as a linen drapers.

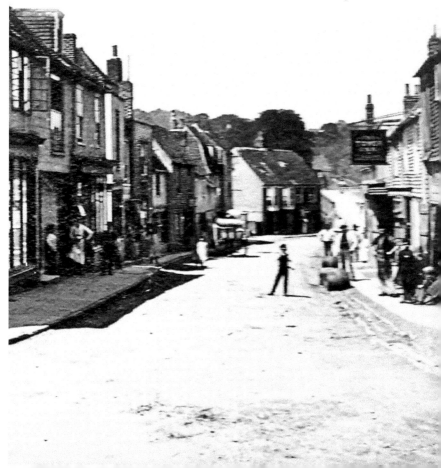

9. THE LANDGATE FROM THE SOUTH

Walking through the arch into the town, the Landgate and buildings adjoining have changed very little from this view in 1877. Tower Forge, on the right, was occupied by Silas Winton, a blacksmith.

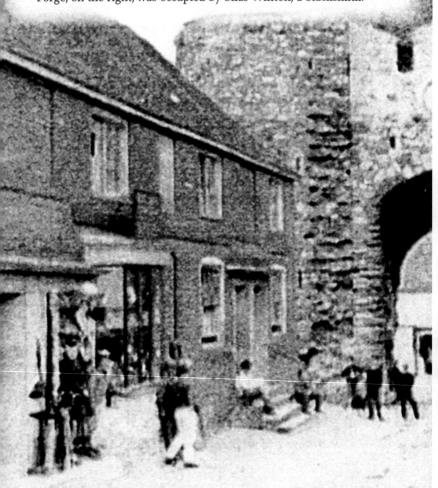

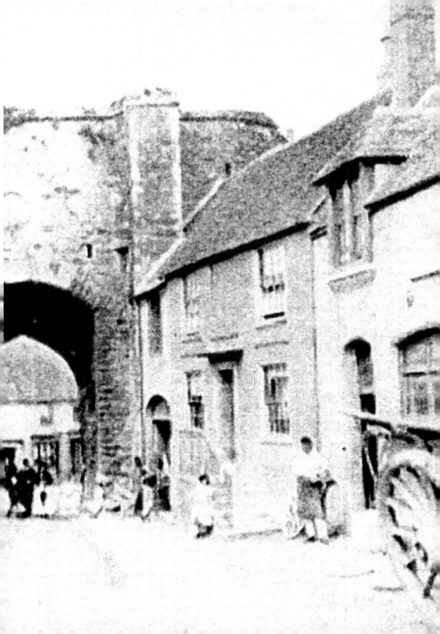

10. THE TOWN SALTS

Walking up Hilder's Cliff, the view on your left includes the Town Salts, previously tidal marshland enclosed as late as 1834 and used since as a recreation ground. This was the venue for lavish entertainment for the children of Rye by Mayor Henry John Gasson, a tent dealer and contractor, in 1905. The riverbank beyond the marquees in the photograph is still the centre of Rye's fishing industry.

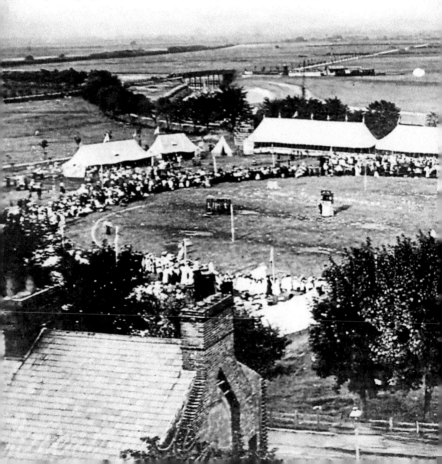

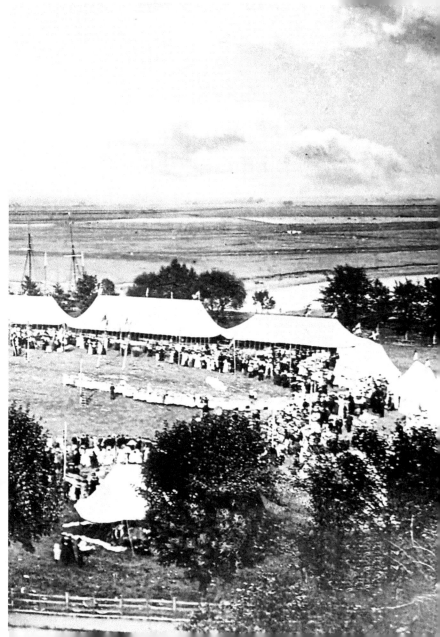

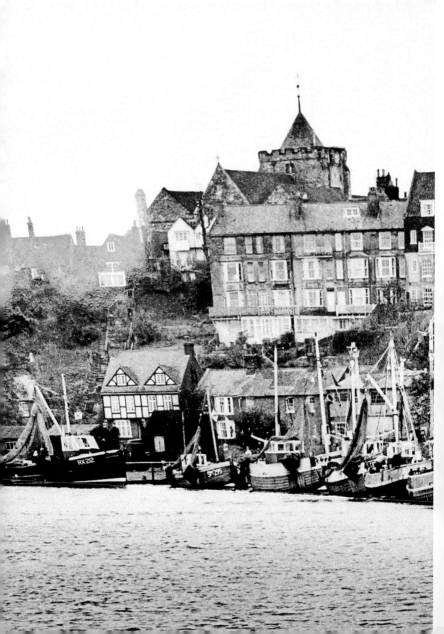

11. THE FISHMARKET FROM THE EAST

This image from the interwar period shows the view from the River Rother at the Fishmarket, looking towards your vantage point. It shows moored fishing boats and the characteristic silhouette of Rye. The fishing quay has since been piled and improved.

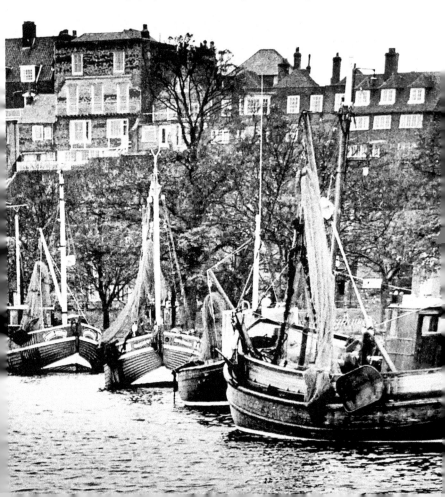

12. GEORGIAN REDEVELOPMENT

The road takes you round to the right into the High Street. Both buildings in this 1850s photograph were built on cleared sites. The bow-fronted building on the left had a long history as a chemists, apparently from 1787. The shopfront and internal fittings are particularly fine features. The building is now the Apothecary Coffee House. The terrace on the right was built in 1736 by James Lamb, a wine merchant, as three houses over massive brick barrel-vaulted wine cellars.

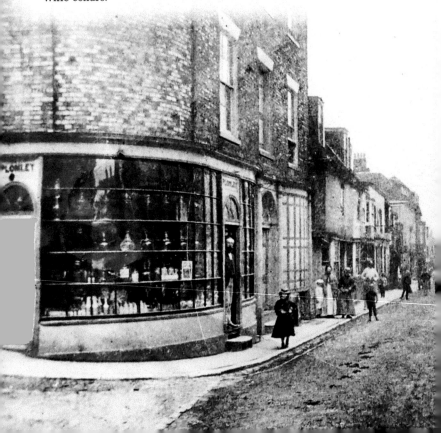

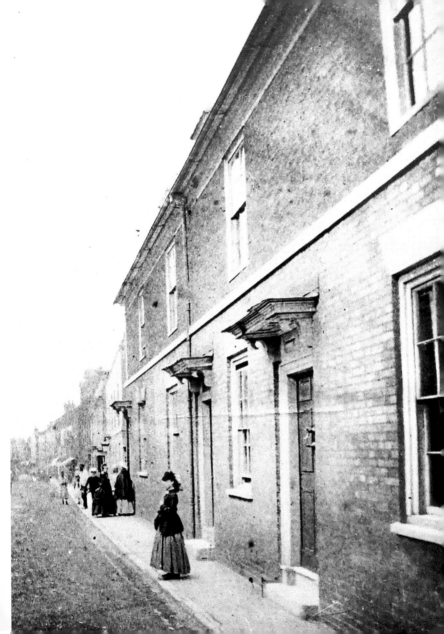

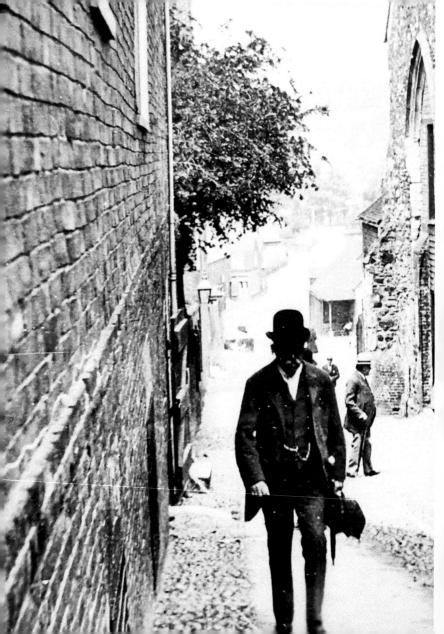

13. THE MONASTERY FROM CONDUIT HILL

Looking to your right from this point, the chapel of the Augustinian friary was built in 1378 on a newly allocated site following a landslip at its earlier location. It was used as a wool store in the nineteenth century and later as a church function room. The photograph shows members of an archaeological society visiting the town on 15 June 1901.

14. EAST STREET

Looking to your left up the hill, East Street leads to the top of the town and the church. This civic possession took place in 1906 when the monastery was dedicated to church use. On the right in this street is one of the two sites now occupied by Rye Castle Museum.

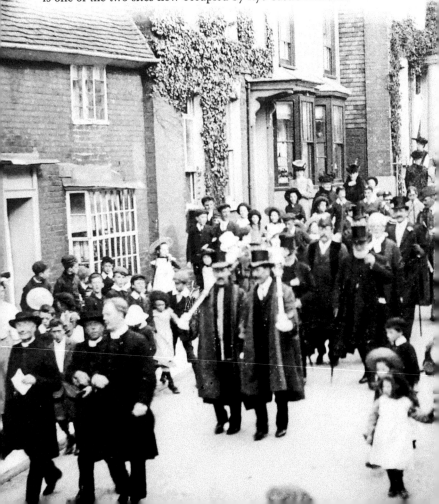

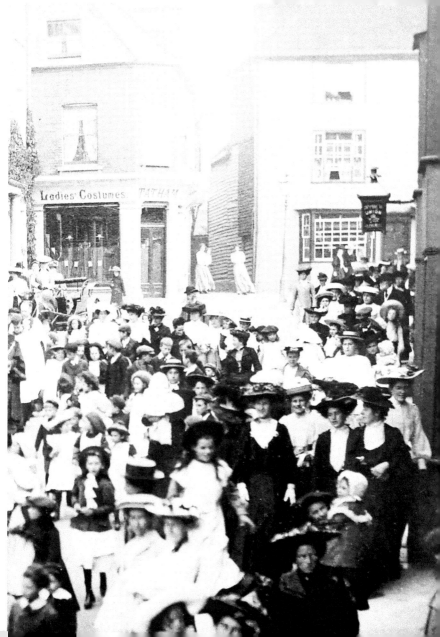

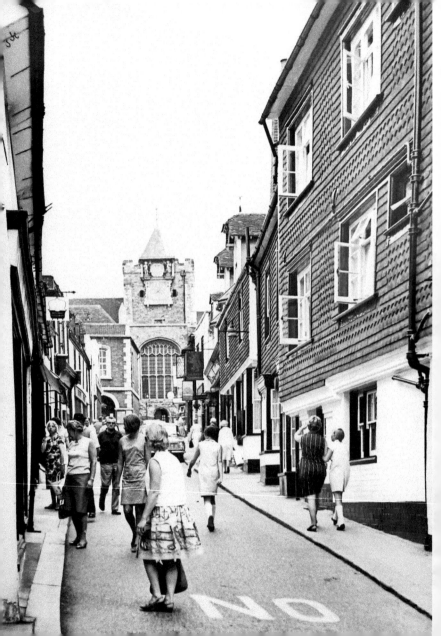

15. LION STREET AND ST MARY'S CHURCH

Moving along the High Street, on your left is another approach road to the church including the well-known view of the clock and Quarter Boys, eighteenth-century cherub figures that strike the quarter hours. The church was founded around 1105 at the highest point in the town, replacing an earlier building to the south.

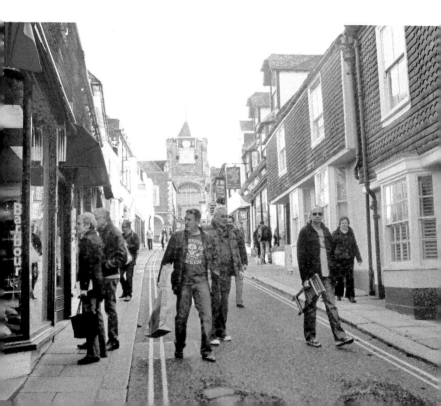

16. THE GEORGE HOTEL AND HIGH STREET

Moving further along the High Street and looking back, this Edwardian view shows the main inn in the town, gas lighting and a range of horse-drawn vehicles. The inn dates from the sixteenth century and was refronted in the Georgian period. The ballroom with a tall oriel window on the right dates from 1819.

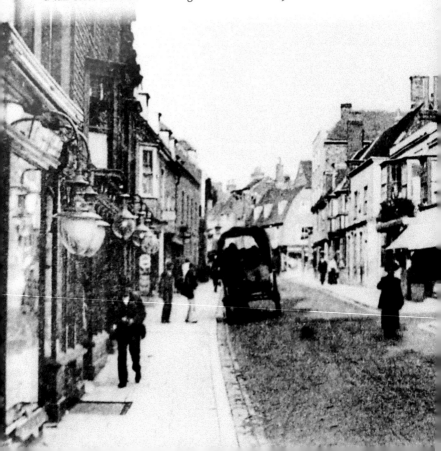

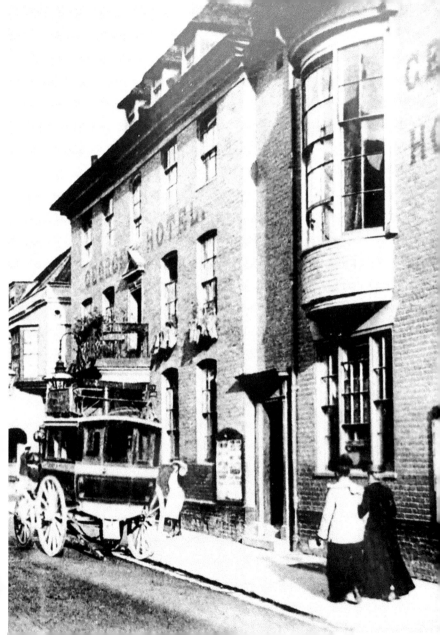

17. ANOTHER HIGH STREET VIEW FROM FURTHER WEST

This view looking back from further on in the street shows mainly nineteenth-century shops, some enclosing earlier Tudor buildings. Some of the shopfronts survive to this day but the bicycles and handcarts are now replaced by parked cars.

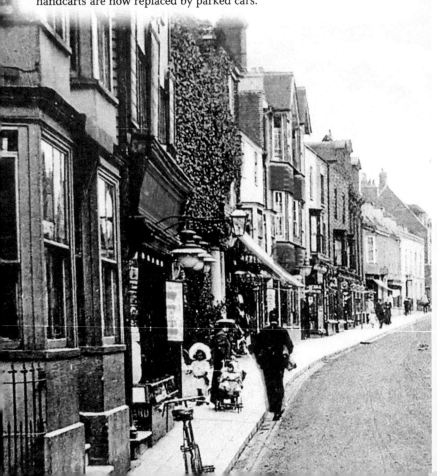

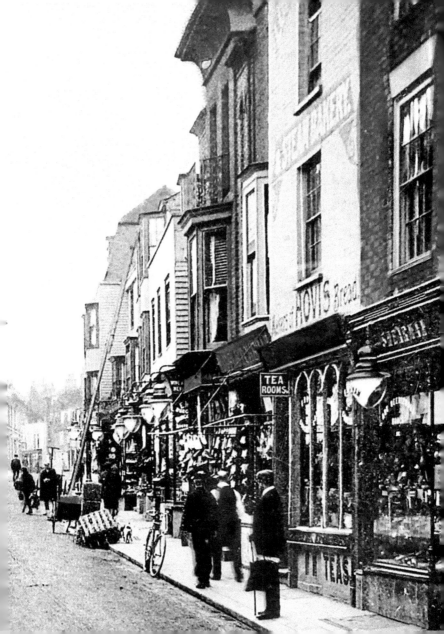

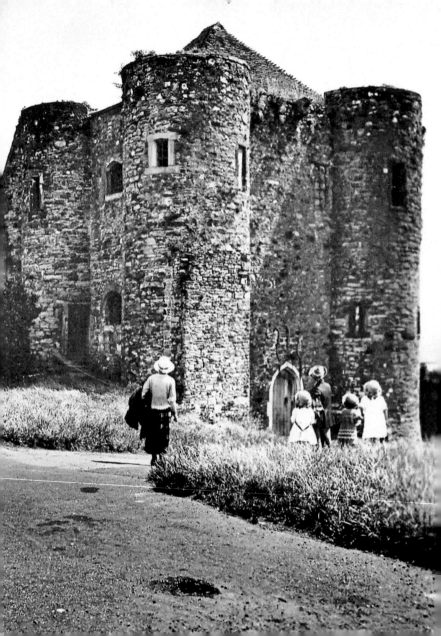

TOUR TWO:
THE TOP OF THE TOWN
18. THE YPRES TOWER –
RYE CASTLE MUSEUM

The starting point for the second tour, the tower was built at the vulnerable shallow sloping south-east corner of the town facing the harbour and was joined by short lengths of town wall. Traditionally dated to *c.* 1250, the tower has recently been reappraised and parallels drawn with similar construction at the Landgate, dating from the late fourteenth century. The tower has been used as Rye's court hall, a later version of which was built on the site of the present town hall in the early fifteenth century. It was sold to a Rye resident John de Ypres, whose name is still attached to the building. It was used as the town's jail from the early sixteenth century to the 1890s. A women's tower and exercise yard were added to the rear of the building in 1837. In 1954 the tower became the home of Rye Castle Museum, one of Rye's tourist attractions. The pyramid roof was destroyed by a bomb in 1942.

19. THE GUNGARDEN –
A HISTORIC GUN BATTERY

Beyond and to the right of the Ypres Tower, this site was used as a gun emplacement from 1458 together with an artificial mound at the Strand. A timber enclosure is shown on the town map of 1772. In its present form the Gungarden dates from 1855, and in 1866 it was in the care of John David Morton, master gunner of the Royal Artillery Coast Brigade. This interwar photograph shows captured German guns placed here after the First World War.

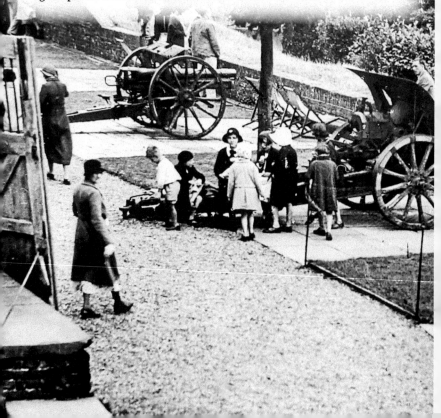

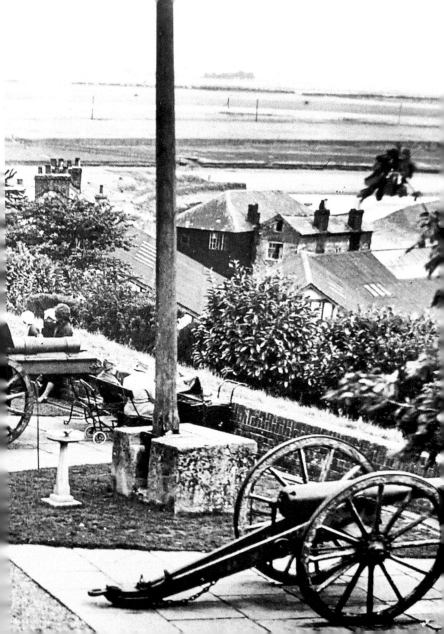

20. THE GUNGARDEN
AND THE YPRES TOWER

This photograph shows the Gungarden laid out as a municipal garden after the Second World War. The structure on the left is a musket wall and ramped platform from which fire could be directed at an attacker from inland. The Gungarden was restored and presented as a historic gun battery by Rother District Council in the 1990s.

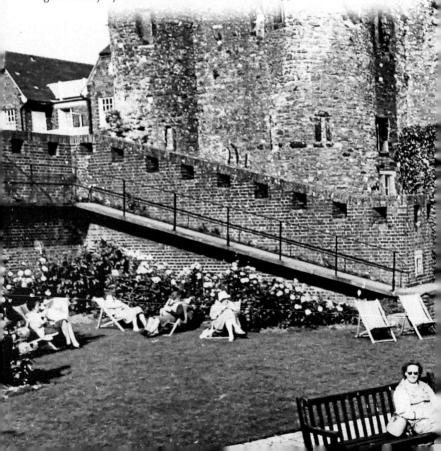

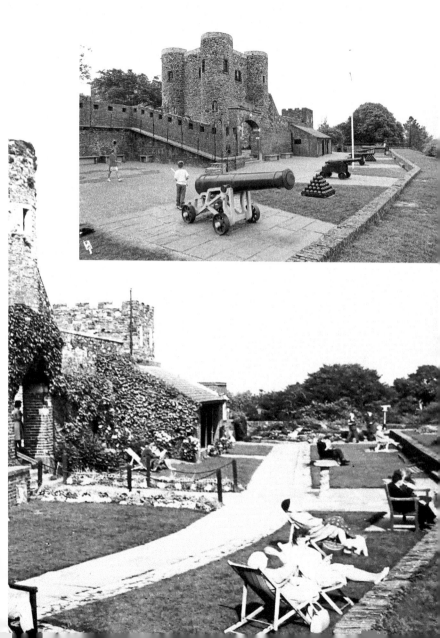

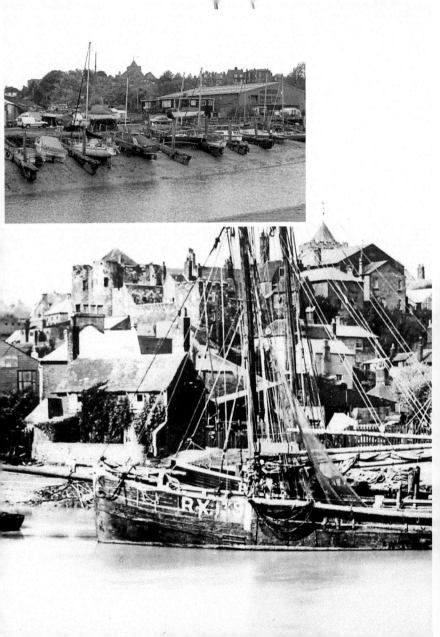

21. VIEW BACK TO THE GUNGARDEN FROM THE RIVER ROTHER

At this area to the east defended by the Gungarden and the Ypres Tower, the tidal River Rother is joined by the Rock Channel (the combined rivers Brede and Tillingham). This photograph from 1901 shows two sailing smacks with nets furled. RX139 was the *Forget Me Not* built in 1874. It finished fishing in 1902. The area is now a leisure boatyard as shown in the modern inset photograph.

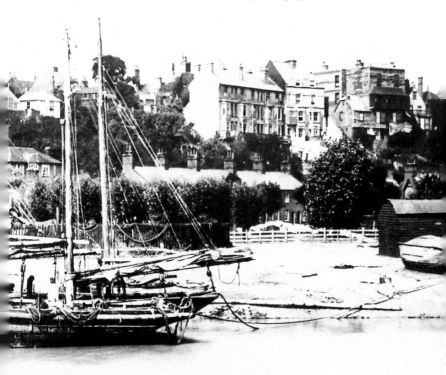

22. ANOTHER VIEW BACK TO THE GUNGARDEN FROM ROCK CHANNEL

This early post-war view shows the setting of Rye from the south and in the foreground the Phillips' boatyard, established from 1890 at this site and only changing hands from the family in recent years. The business was known for clinker-built fishing boats (made from overlapping wood planks). It now provides moorings and repairs.

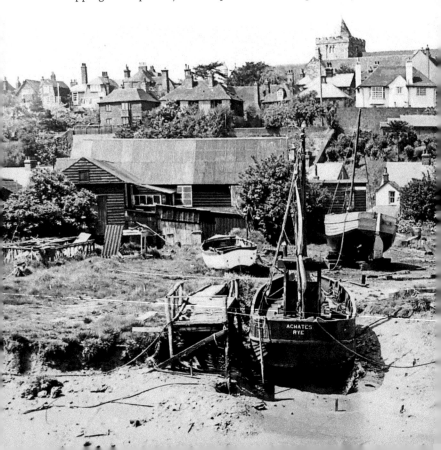

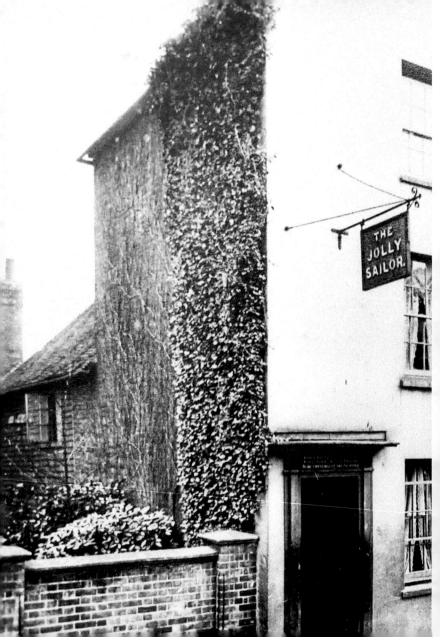

THE
JOLLY
SAILOR.

23. CHURCH SQUARE

Moving away from the Gungarden eastwards on the south side of Church Square, this photograph shows the Jolly Sailor, a lodging house built in 1838 to accommodate passengers travelling by steamer to France. The timber-framed buildings on the right date from the medieval period and later infilling in Rye's boom in Tudor times. They were in poor repair in the interwar period and were refronted by an investor using old timbers.

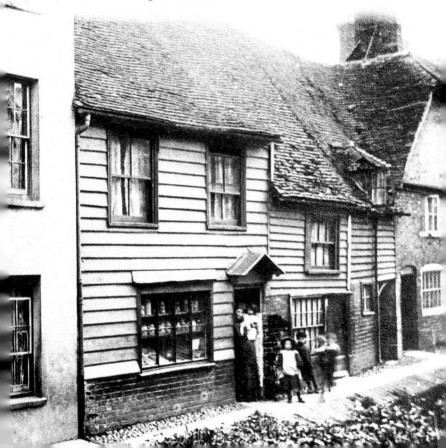

24. ST MARY'S CHURCH

This view from the south-east corner of the churchyard shows the large size of the church and its spacious setting on the south in contrast with the closely packed buildings and streets on the north side. The church retains early Norman detailing at the transepts. The nave dates from later in the twelfth century and the upper stage of the tower and pyramid spire from the fourteenth century. The spire itself was rebuilt in 1701.

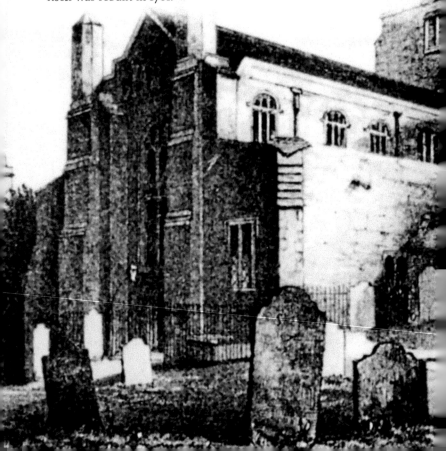

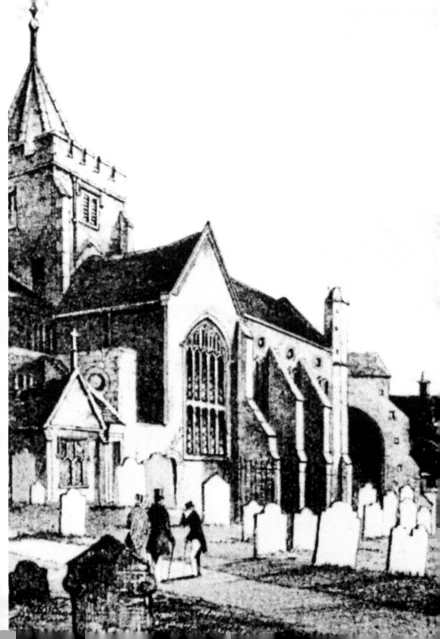

25. THE TOWN HALL

Moving around the west and north sides of the Church Square and past the church, the court hall at this location, dating from the fifteenth century, was rebuilt by the Corporation in 1742 to the design of London architect Andrews Jelf. The building is an elegant example of a Georgian town hall and has an arcaded market beneath. The drawing dates from around 1825 and shows market traders in front of the arches of the Butter Market. The modern inset view shows how little the building has been altered.

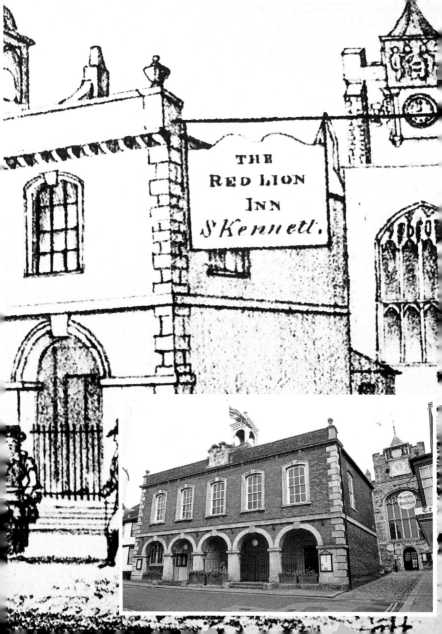

THE
RED LION
INN
S.^t Kennett.

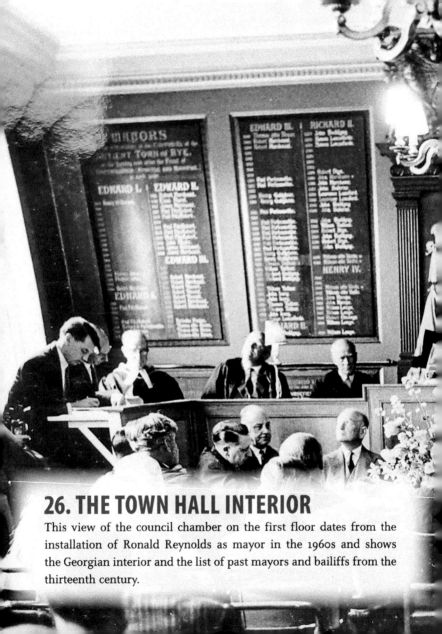

26. THE TOWN HALL INTERIOR

This view of the council chamber on the first floor dates from the installation of Ronald Reynolds as mayor in the 1960s and shows the Georgian interior and the list of past mayors and bailiffs from the thirteenth century.

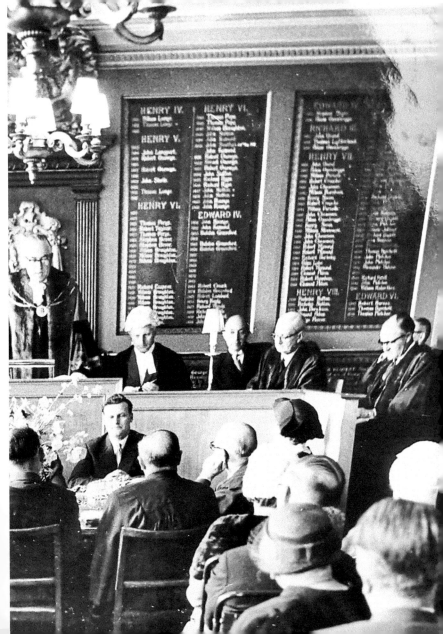

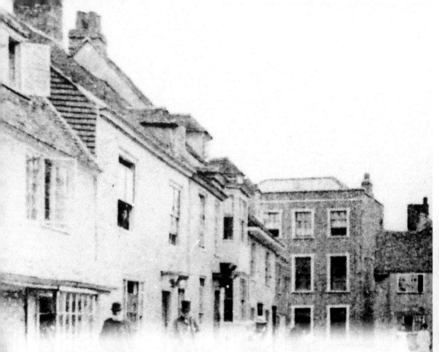

27. MARKET STREET

Looking to the left of the town hall, this wide street was the original medieval marketplace, which probably started as removable booths in front of the church. The large house in the background was built in 1816 and is timber framed, being brick at the front only. Most of the other buildings are medieval. The building with first floor overhang on the right is the Flushing Inn, home of the Rye murderer John Breeds, a butcher who was fined by the mayor in 1742 for short weight and murdered the mayor's brother-in-law by mistake after the mayor had lent him his coat. The case attracted national press attention including the fact that the Corporation exercised its prerogative as one of the Cinque Ports to try, convict and hang the culprit, whose gibbet and skull are still stored in the town hall.

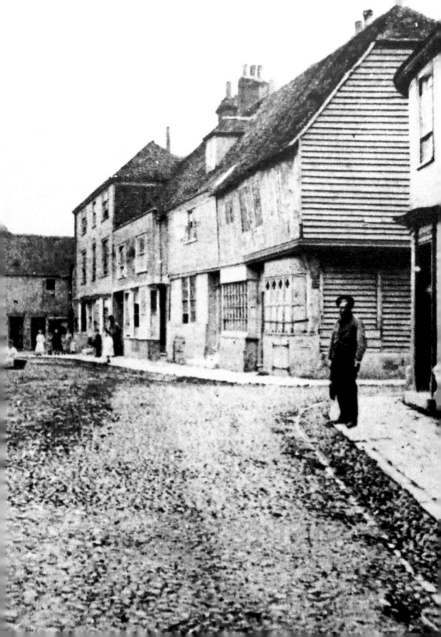

28. PUMP STREET

Immediately on the right before reaching Flushing House, this short street, now known as part of Church Square, leads back to the starting point for this tour at the Ypres Tower. The street contains a well-known feat of Georgian engineering, the elliptical water cistern and cupola, a fine example of brickwork dating from 1735 when the town's water supply was improved. The pump adjoining the cistern dates from the 1820s and gave its name to the street.

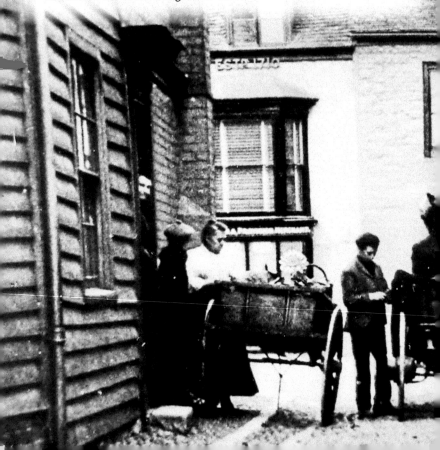

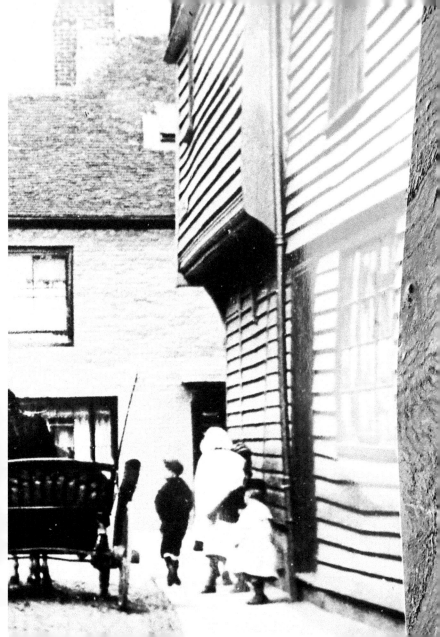

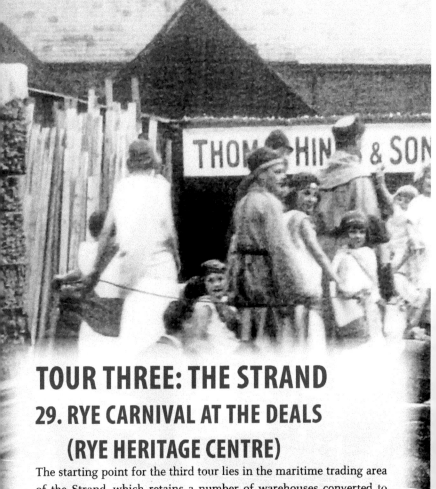

TOUR THREE: THE STRAND
29. RYE CARNIVAL AT THE DEALS
(RYE HERITAGE CENTRE)

The starting point for the third tour lies in the maritime trading area of the Strand, which retains a number of warehouses converted to shops and flats from their original coal, corn and timber use. The early post-war carnival is seen passing Thomas Hinds & Sons timber merchants yard, one of whose warehouses was converted to form the Rye Town Model and Heritage Centre in the 1980s.

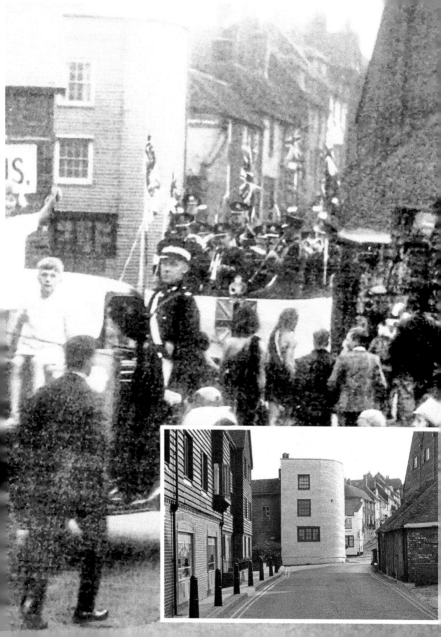

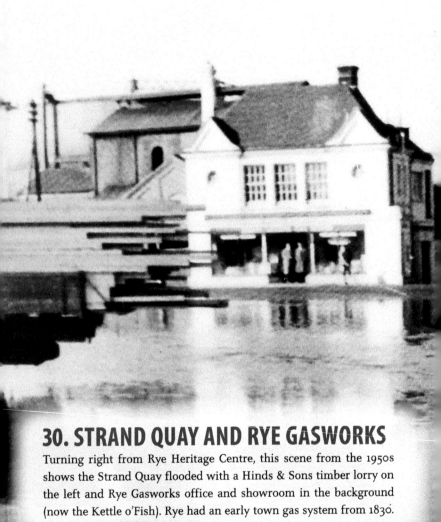

30. STRAND QUAY AND RYE GASWORKS

Turning right from Rye Heritage Centre, this scene from the 1950s shows the Strand Quay flooded with a Hinds & Sons timber lorry on the left and Rye Gasworks office and showroom in the background (now the Kettle o'Fish). Rye had an early town gas system from 1830.

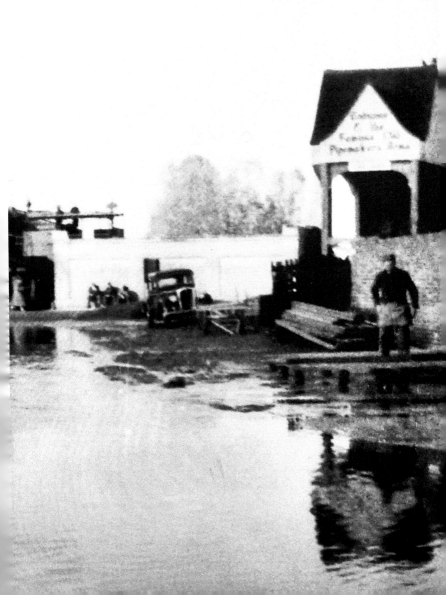

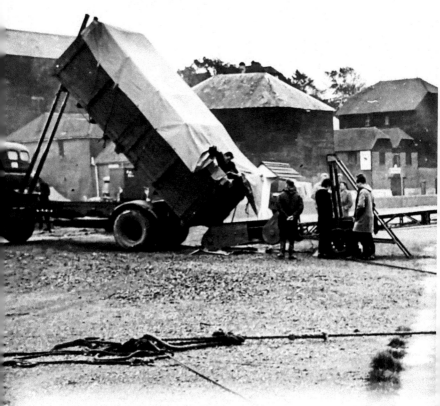

31. THE STRAND QUAY
AND WAREHOUSES

Looking back towards the Heritage Centre, this photograph from the 1950s shows a conveyor loading cargo from the lorry to the coaster. The brick and weather-boarded warehouses date from the early nineteenth century and served the coal and corn merchants based at the Strand.

EDWARD STONE
ROCHESTER

32. THE STRAND ROUNDABOUT

In front of the Kettle o'Fish, the Strand roundabout now takes the A259 trunk road over the river towards Hastings. The photograph shows a long distance race in 1900. In the background is Charles Standen's wheelwright workshop with a wagon and other materials outside. Most of the building survives today.

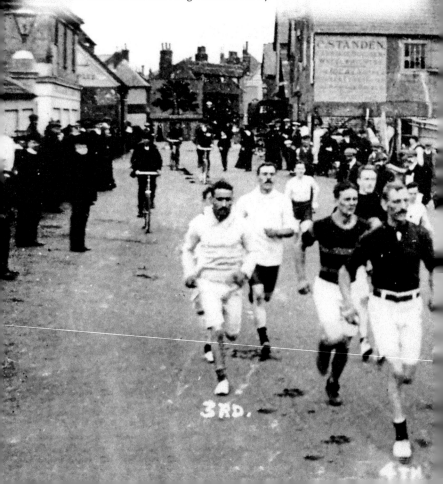

3RD.

4TH

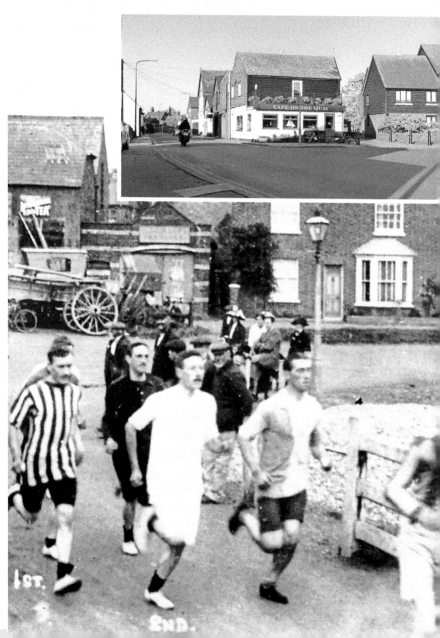

CAFÉ ON THE QUAY

1ST. 2ND.

33. THE PIPEMAKERS ARMS

Moving into the town from the roundabout, this public house at the junction of Wish Street and Wish Ward is pictured here in the 1900s before interwar alterations and an extension. The row of cottages behind was largely destroyed in the Second World War; one remains as part of the adapted public house.

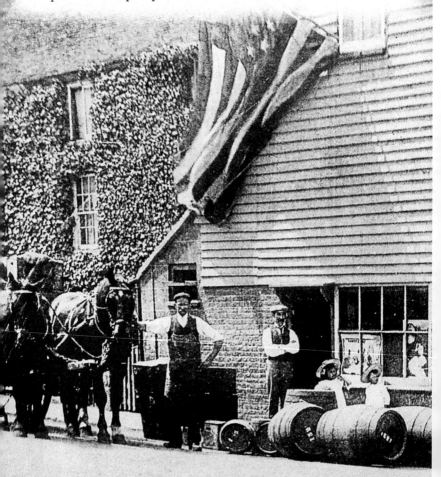

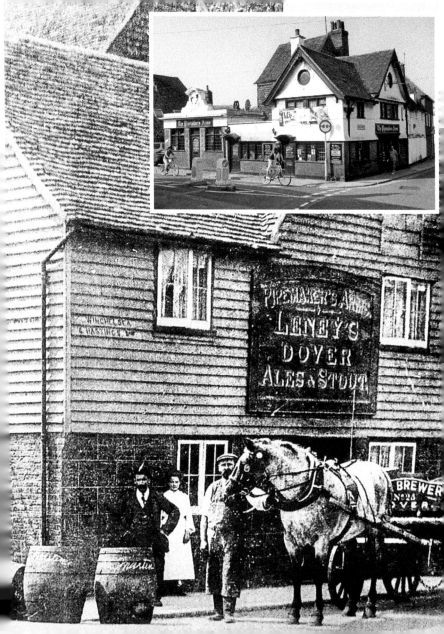

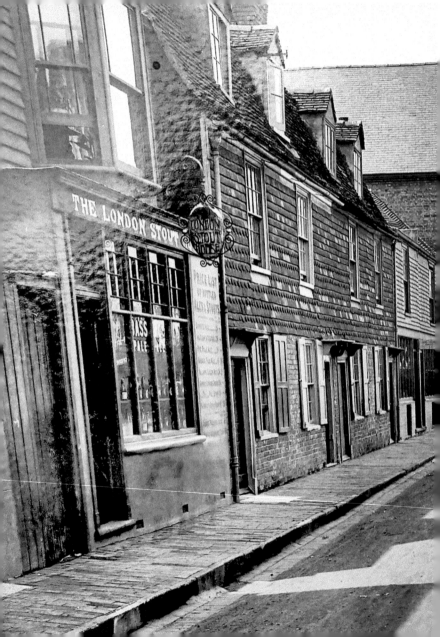

34. FERRY ROAD

Moving on from the Pipemakers Arms, the road bears left to Ferry Road, a secondary land approach to the town in early times from the high ground to the west having a ferry crossing until a bridge was built in the eighteenth century. Pictured are three public houses, **The London Stout** on the left and (captioned) the **New Inn** and **Queen Adelaide**. The photograph is one of several illustrating public houses as part of a licensing review in the 1900s.

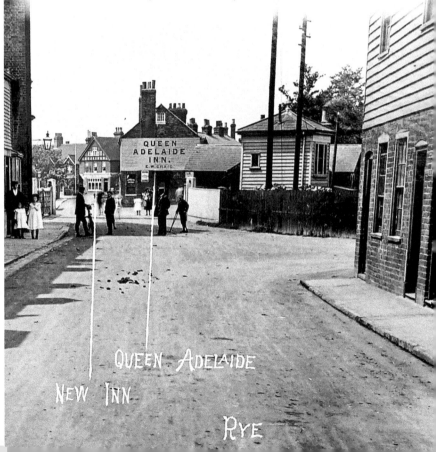

QUEEN ADELAIDE

NEW INN

RYE

35. THE WESTERN END OF CINQUE PORTS STREET

Ferry Road is also joined by Cinque Ports Street at this western approach to the town, The King's Arms Inn was another public house closed after 1901. It has been demolished and a lay-by constructed. Beyond that, our route passes up to the right through Needles Passage, one of many alleys between the main streets and the historic town wall, which is crossed by the steps in the passage.

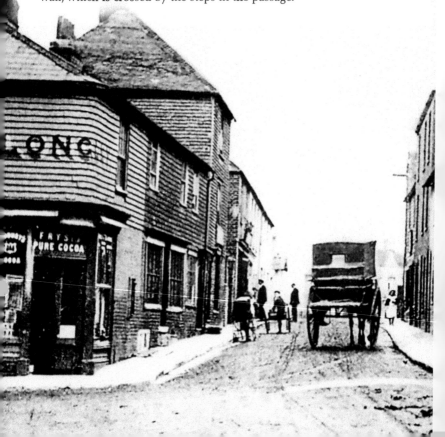

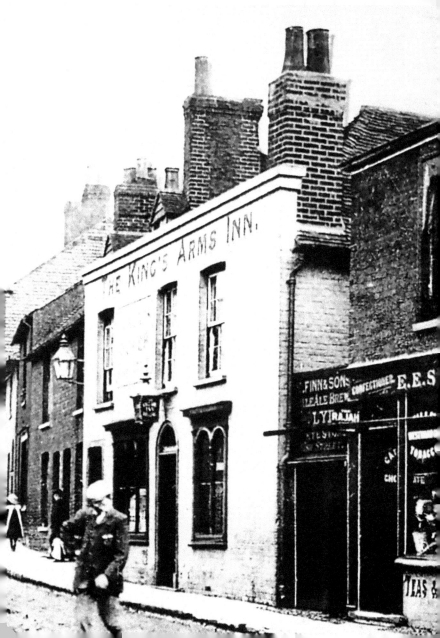

36. THE MINT, LOOKING WEST

From the upper end of Needles Passage our route turns left up The Mint, a continuation of the High Street. Looking back from the top of the slope, this view shows the picturesque winding street adjoined by buildings, some of which are the earliest in the town. The Bell Inn on the right dates in part from the fourteenth century.

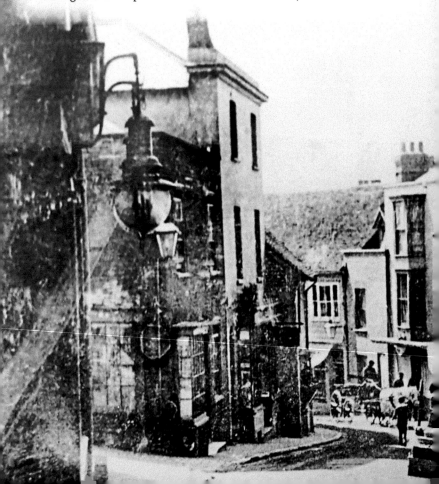

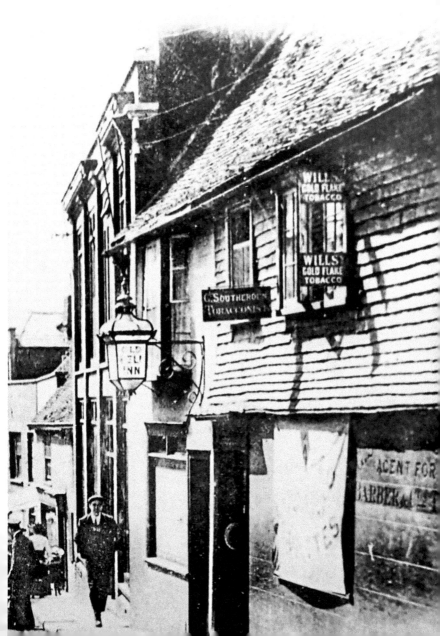

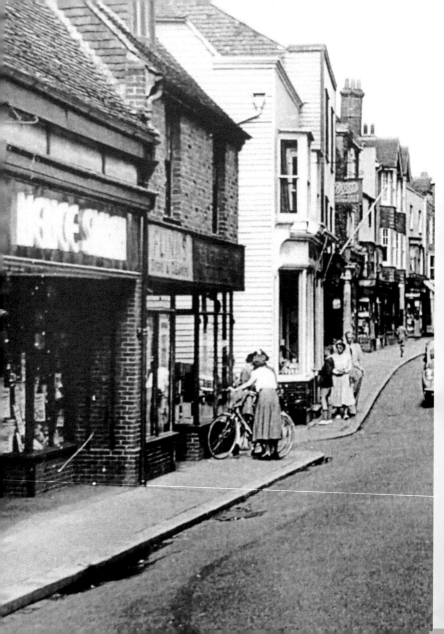

37. THE WESTERN END OF THE HIGH STREET

Our route extends to the western end of the main commercial street where this post-war view shows early multiple retailers: Mence Smith (ironmongers), Flinns (cleaners) and Boots (chemist), all established in Rye in the 1930s. Very little has changed of these buildings and shopfronts. From this viewpoint turn right up West Street.

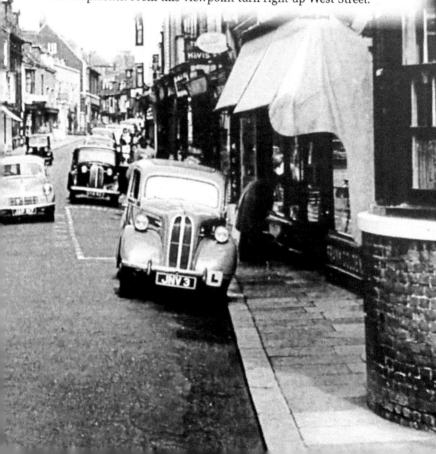

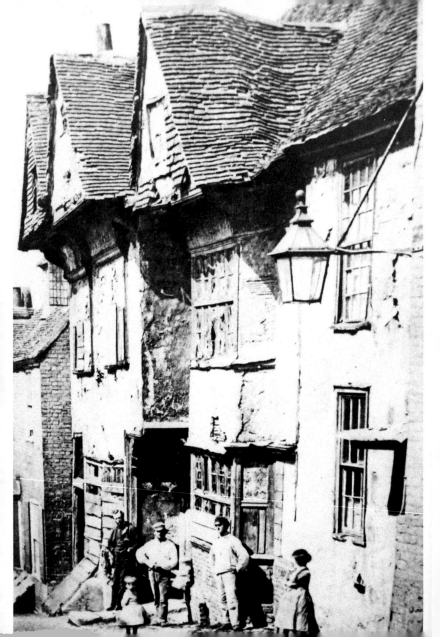

38. MERMAID STREET

When you are almost at the top of West Street, turn right. This is perhaps the best known of Rye's historic cobbled streets, being steep and adjoined by picturesque buildings. This, the Old Hospital, is an impressive merchant's house built in 1576. Its name dates from the Napoleonic Wars when it was a hospital for soldiers. By the mid-nineteenth century it was derelict, as shown on the left. By 1872 it was restored and named Jeake's House after its seventeenth-century owner, the merchant, diarist and astrologer Samuel Jeake the Younger. In the background the road leads down to the warehouses at the Strand.

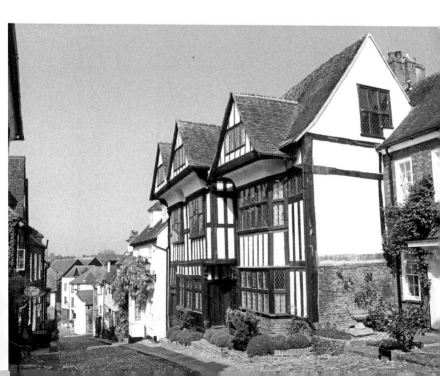

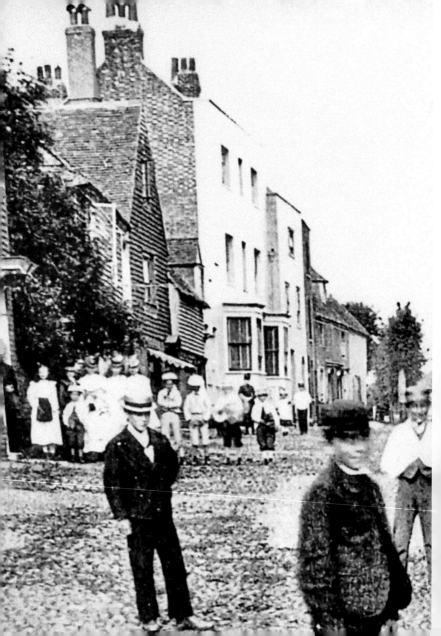

39. WATCHBELL STREET

Almost at the foot of Mermaid Street, our route turns left up a clifftop path, Trader's Passage, from the top of which we obtain this view of the western end of Watchbell Street. During the Edwardian period the housing here catered for a social mix including wealthy shipbuilders, solicitors and poor fishermen. Most of the buildings are unaltered.

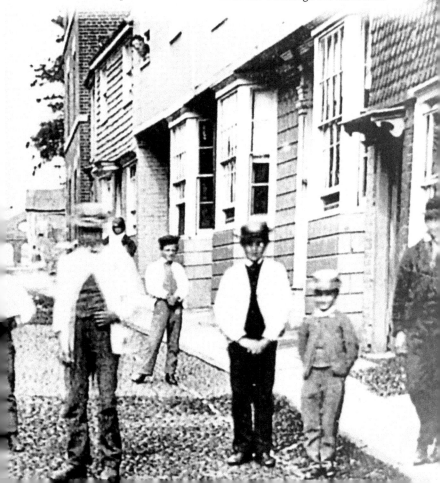

40. A TRAWLER TAKES SHAPE

From our vantage point at the end of Watchbell Street, we look west over the Brede Valley towards Winchelsea and over the area immediately below, which was a shipbuilding yard in the 1900s. This photograph shows the frames for a deep-sea trawler being assembled with a pulley. The yard was a large employer, building mainly sailing trawlers for the North Sea ports.

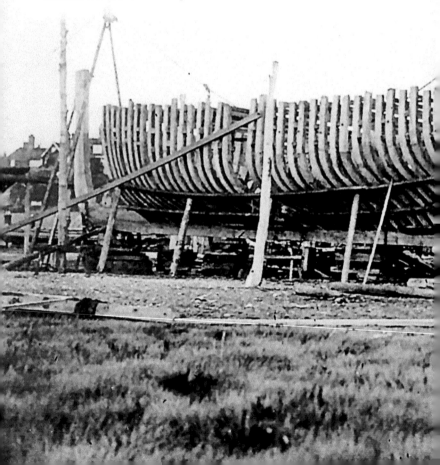

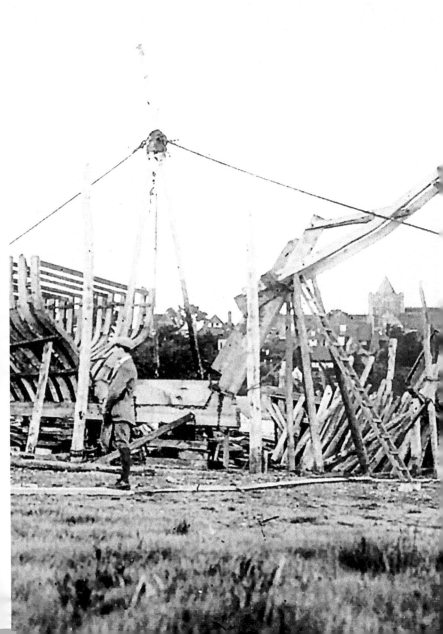

41. A SHIP LAUNCH GROUP

This group shows a number of men, women and children in varied dress among scaffolding and wood debris, presumably the aftermath of a launch. The figure with moustache centre left is Henry John Gasson, a tent dealer whose entertainment for the children of Rye was seen in earlier photographs. He was presumably an investor in the ship.

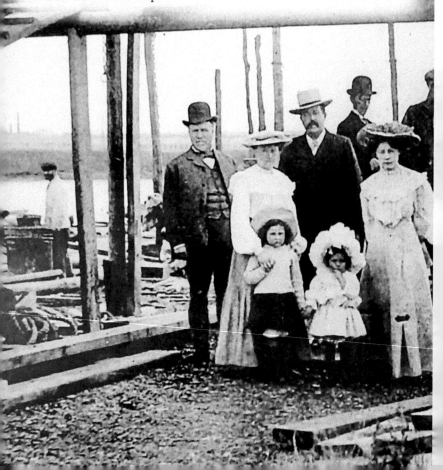

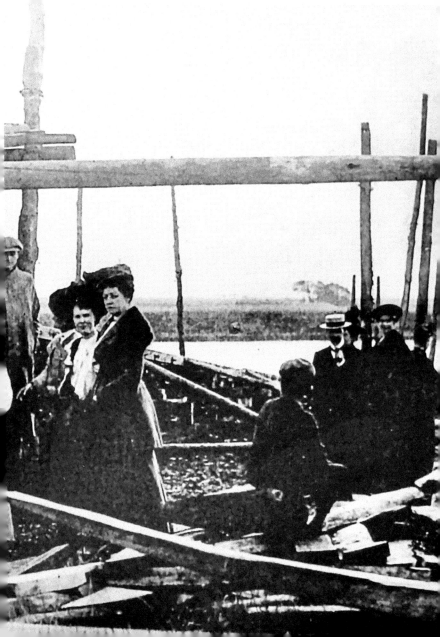

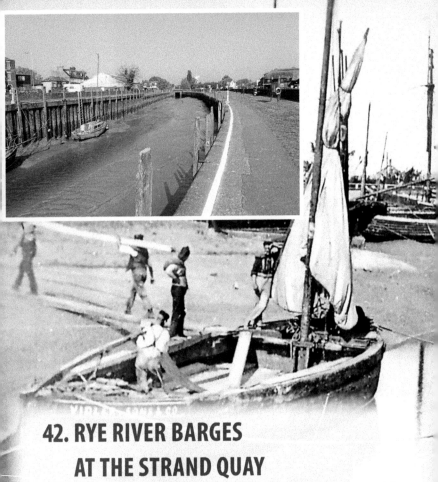

42. RYE RIVER BARGES
AT THE STRAND QUAY

Returning to the Strand down the steps from Watchbell Street and looking to the right, this Edwardian view shows river sailing barges, a part of the business of Vidler & Sons, Lloyds agents, shipowners, merchants and ship agents. In the background is the Tillingham bridge and Rye windmill. The modern inset view shows the starker appearance of the present piled quay.

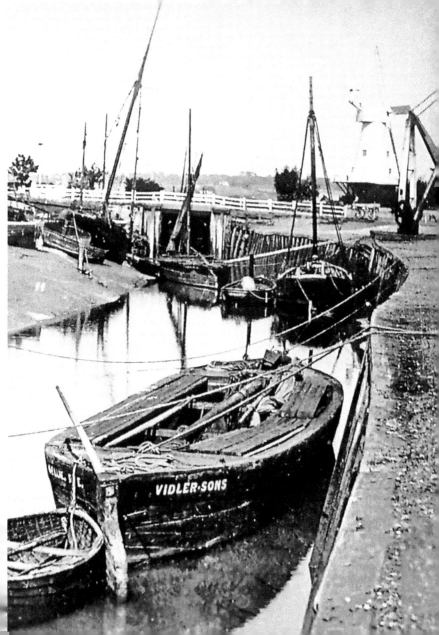

43. SITE OF THE STRAND GATE

Returning to the Heritage Centre past the Ship Inn on the left, there is a junction of several roads. The Strand Gate stood at the junction of Mermaid Street and The Mint. It is illustrated in Jeake's map of 1667 as being similar in appearance to the Landgate. It was demolished in the eighteenth century. The volunteer fire brigade is seen here in 1890 with its eighteenth-century fire engine, now preserved in the East Street site of Rye Castle Museum.

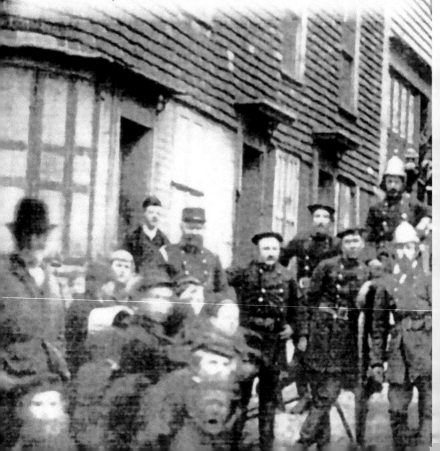

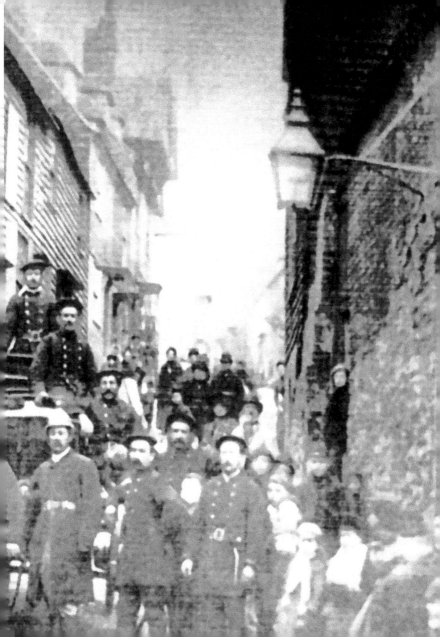

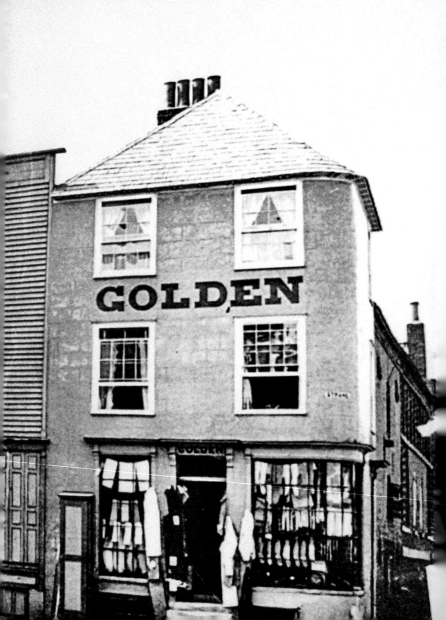

44. HISTORIC SHOPFRONTS AT THE STRAND

These buildings have changed very little since the early nineteenth century. Edward James Heath was listed as a linen draper and clothier at the Strand in 1839 and William Golden followed him from 1858 to 1867. Both the stucco and the weather-boarded buildings have unusual curved corners and contemporary wood shopfronts. From this spot, the route turns left to return to the Heritage Centre.

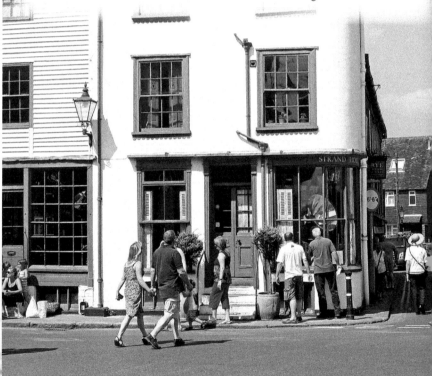

Also available from Amberley Publishing

ALAN DICKINSON

RYE AND AROUND

From Old Photographs

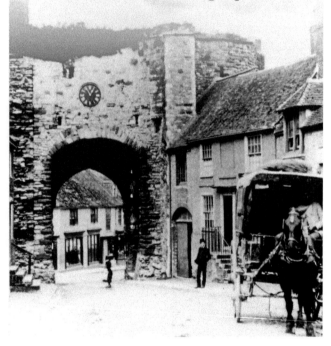

A charming selection of old photographs of Rye and the surrounding area.
978 1 4456 5899 5
Available to order direct 01453 847 800
www.amberley-books.com